LEARN TO DRAW
COOL STUFF

For Young Artists

by Elizabeth H Taylor

LEARN TO DRAW COOL STUFF FOR YOUNG ARTIST

An Exclusive And Easy Pencil Drawing Book That Turns Everyone A Genuine Artist

Illustrations by Elizabeth H. Taylor

Hi, I'm a curious cat. If this book works wonder for you, send me your pencil drawing so I can follow your progress of becoming an artist.

Your #1 fan,

Elizabeth H. Taylor

✉ drawing.with.h.taylor@gmail.com

TABLE OF CONTENT

Pencil Drawing: Overview

Pencil Drawing: Practices

WHY YOU SHOULD USE THIS BOOK

This book gives you detailed steps to successfully draw a beautiful realistic style artwork using pencils, even with zero experience in pencil drawing. Moreover, it focuses on the basics of shading techniques and guides you to master those skills. As a result, you can avoid the common mistake of pencil shading to create a more satisfying and convincing drawing.

Your drawing results after using this book might look like the illustrations below:

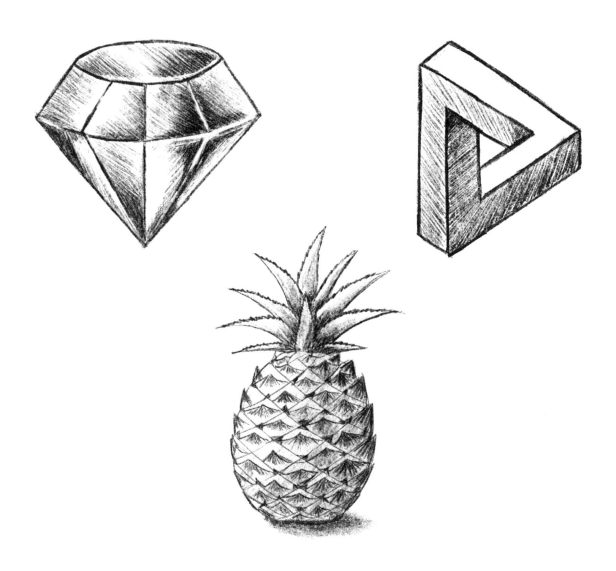

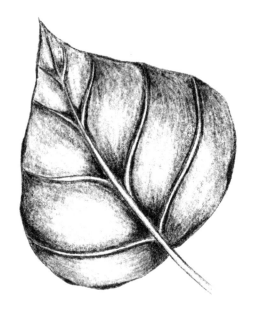

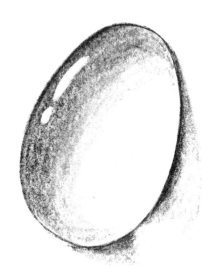

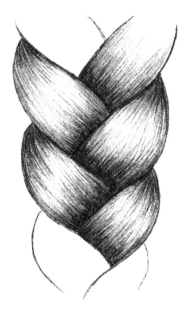

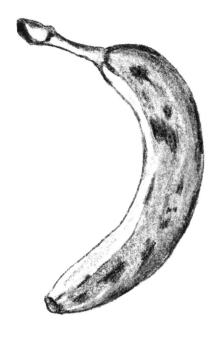

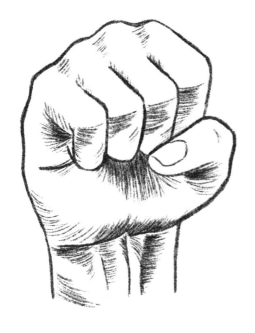

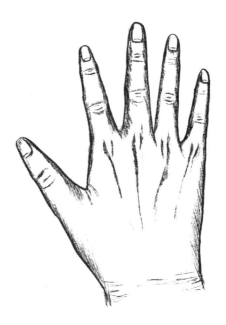

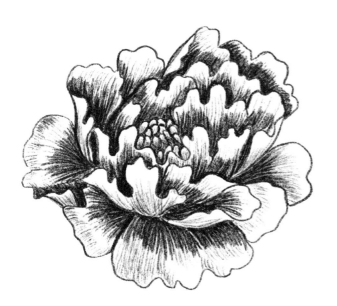

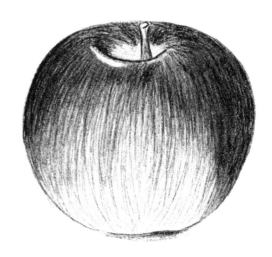

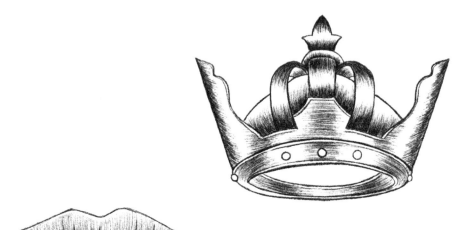

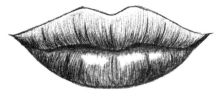

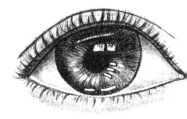

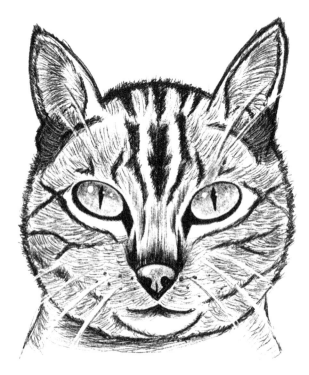

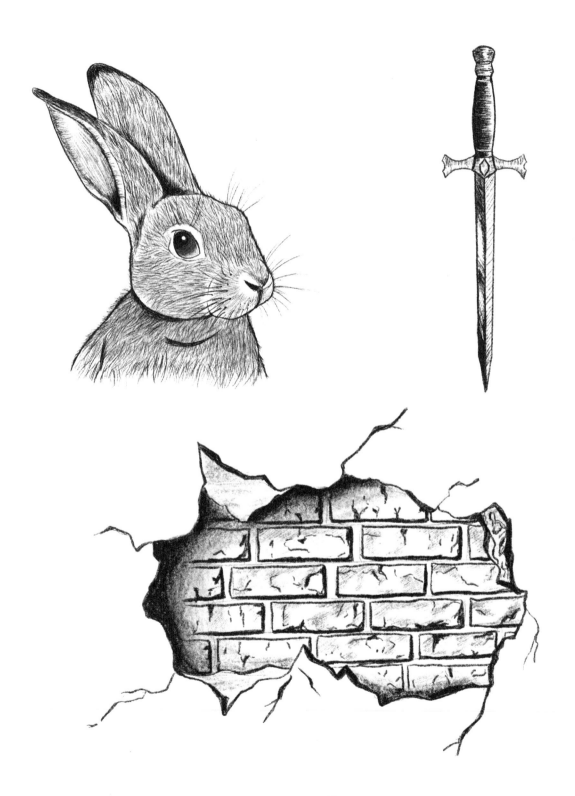

DRAWING TOOLS USING IN THIS BOOK

1. For Sketching:

The 2B, 4B, 6B, HB pencils

A Mechanical pencil

2. Adding highlight:

The kneaded erasers

You can use white ink gel
pen or white marker instead

3. Remove the sketch containers:

The mechanical erasers

A pencil eraser

4.. Others

#1 Fan of Pencil: a pencil sharpener

A lot of high quality papers

THE PENCIL DRAWING WORLDS ARE AWAITING...

OVERVIEW

In pencil drawing, there are two primary sections: pencil sketching and pencil shading. Pencil sketching helps visualize the object meanwhile pencil shading give a soul to that object.

AN INTRODUCTORY TO PENCIL SHADING

The most important function of shading is creating the illusion of light and shadow in a drawing, making it realistic as appearing three dimensional.

★ Example:

Take a look at the cylinders below: The B cylinder appears as a convincing image, whereas the A cylinder looks flat and plain. This happens because pencil shading is applied on the B cylinder.

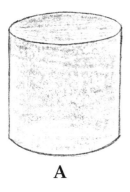

A

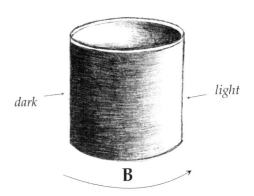

dark *light*

B

transparency from dark to light

The B cylinder has light and shadow areas on it, and between both areas there is a transparent area - from darker to lighter color. That's the key of shading. In another word, shading is a coloring technique using only pencil to create the transparency from darker to lighter and in reverse.

dark ——————→ light

transparent

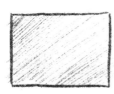

This is normal pencil coloring

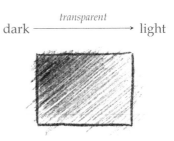

This is pencil shading

SHADING TECHNIQUES

There are two primary techniques in shading - one is often used by professionals, anothe
one is great for beginners.

Technique 1:

This approach is for people who are professional in shading, by drawing zic-zac lines continuously and
have good skill on controlling the hardness of hand drawing pressure. You can begin with harder drawing
pressure, and finish with lighter drawing pressure, or choosing to do it completely in reverse.

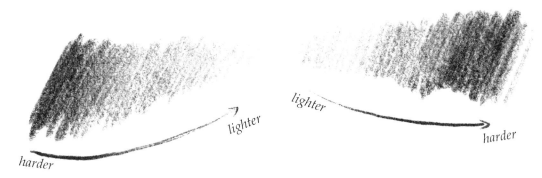

Notice: This approach is not recommended for someone at beginner level.

Technique 2:

Creating different groups of parallel lines, where the biggest group will be at the bottom of the drawing,
following by smaller and smaller groups in order to get the satisfactory illusion of light.

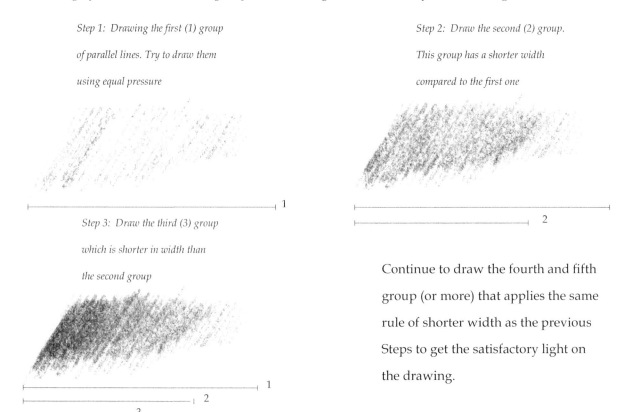

Step 1: Drawing the first (1) group

of parallel lines. Try to draw them

using equal pressure

Step 2: Draw the second (2) group.

This group has a shorter width

compared to the first one

Step 3: Draw the third (3) group

which is shorter in width than

the second group

Continue to draw the fourth and fifth
group (or more) that applies the same
rule of shorter width as the previous
Steps to get the satisfactory light on
the drawing.

STROKE TYPES

 This is the common shading technique that uses continuous zic-zac lines. Except the zic-zac stroke mentioned at technique 1, there are 08 different stroke types.

1. Hatching/Parallel Hatching

Step 1:

Draw a group of parallel lines (GOPL)

Step 2:

Draw the 2nd GOPL above the 1st one

Step 3:

Draw the 3rd GOPL above 1st and 2nd ones.

Step 4:

Continue to draw the 4th GOPL applying the same rule as previous steps until hitting the satisfactory illusion of light.

★ **Pro Tip:** - Those lines are not completely horizontal.

- Lines in the new GOPL are parallel to the old one.

- New GOPL has a shorter width compared to the old one. This is a **EXTREMELY IMPORTANT** tip to apply in the practice section of this book

2. Cross Hatching

Step 1:

Draw a group of parallel lines (GOPL)

Step 2:

Draw the 2nd GOPL that is unparallel compared to the 1st one.

Step 3:

Draw the 3rd GOPL. Those lines tends to cross to the 1st and 2nd one

Step 4:

Draw the 4th GOPL. Those lines tends to cross to the previous GOPLs

3. Contour Hatching

This technique is similar to Parallel Hatching (1), but rather than using parallel lines, we use the parallel curves

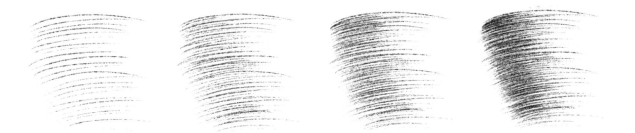

4. Cross Countour Hatching

This technique is similar to cross hatching (2), except replacing the parallel lines by parallel curves.

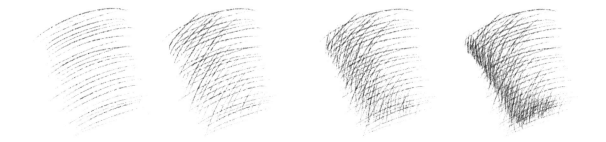

5. Springs

This technique uses random spring shapes for shading

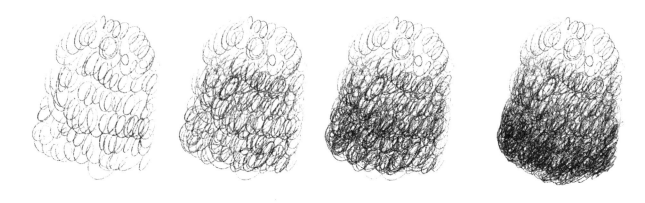

6. Random Lines

A shading technique that uses random lines without rule to create the illusion of light for an object

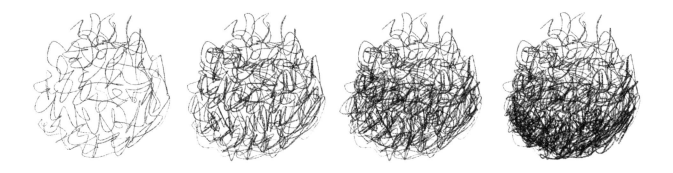

7. Stipping:

This technique uses a variety groups of points for shading

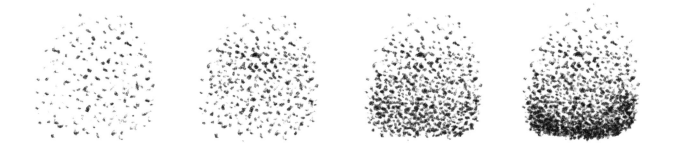

8. Freestyle

This technique uses use random objects (such as hearts) to form a group of them for the purpose of shading.

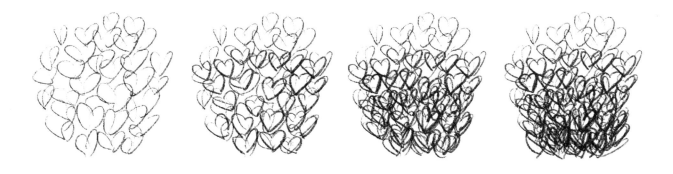

Summary: Whatever stroke types you choose, the ultimate purpose of shading is creating the illusion of light and three-dimensional of an object, by making transparency from dark area to light area and in reverse. Each object can be shaded by one or more techniques depending on the object's texture. This topic will be covered in the practice section.

A COMMON MISTAKE IN SHADING TECHNIQUES

At the beginning, we often create a clear boundary between two GOPL unintentionally. This mistake can decrease the quality and satisfaction of the drawing.

The figure C illustrates this common mistake. The clear boundary makes a poor shading quality, turn the drawing into plain and unrealistic one

The figure D illustrates the right way of shading. Between the GOPL there is a vague boundary, help the drawing more satisfy and vivid.

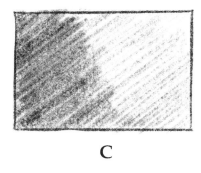

C

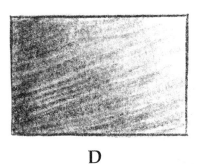

D

The reason behind this common mistake lies in how each line was drawn. We often draw each line with the same power of hand pressure, which leads to an equal darkness distributing on each line (we call them "ED line"). When we create a GOPL from those lines and apply the shading techniques, the clear boundary will appear.

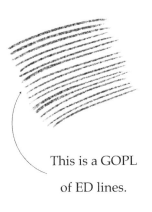

This is a GOPL
of ED lines.

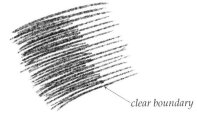

clear boundary

When we draw the 2nd GOPL above the 1st one, this will create a clear boundary between 1st and 2nd GOPL.

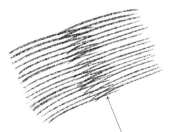

This clear form of boundary will decrease
the quality of the final drawing

How To Fix

Practice to draw with better control of hand pressure, by drawing with harder pressure at the beginning, and lighter pressure at the end. You can feel free to do it in reverse.

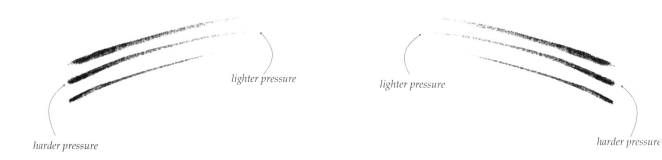

When you master this drawing technique, the GOPL you create is ready for shading. The boundary between each GOPL you use will be unclear, make your drawing more vivid and convincing.

★ **Example:** These figures below demonstrate how the right shading technique is executed.

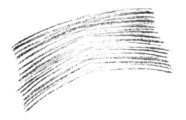

These lines are drawn with harder pressure from the left and lighter pressure to the right.

When the 2ⁿᵈ GOPL is drawn above the 1ˢᵗ one, the boundary between those groups is unclear

This technique help the final drawing become more realistic and satisfying

ADVANCED DRAWING TIPS

1. Line Thickness Control

You can control the thickness of each shading line by adjusting how you put the pencil on the paper when drawing

E

The larger alpha degree is, the thiner and sharper line will be created.

F

The smaller alpha degree, the thicker line will be created.

This is the thin pencil zic-zac lines that we created when we put the pencil tip as at the figure E.

This is the thick pencil zic-zac lines that we created when we put the pencil tip as at the figure F

2. Golden Pencil Holding Gesture

The way we hold a pencil for writing should be different to holding it for drawing.

When we write something, we often do it while our fingers tend to be close to the pencil tip.

But when we draw, we should put our fingers far the pencil tip. This could help us feel more comfortable to control hand pressure, help improve the final quality of the drawing.

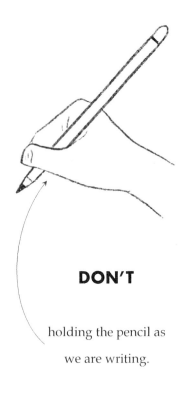

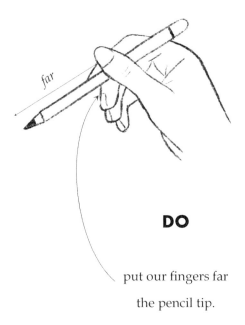

DON'T

holding the pencil as
we are writing.

DO

put our fingers far
the pencil tip.

3. Drawing A Circle Without Tools

We usually find it hard to draw a perfect circle only using our bare hand. This tip will help you draw a nearly-perfect circle without any tool.

Try to practice drawing circle without using tools. Tools are easy to use and help us to get the right shape, but it will turn the drawing to be unnatural. The drawing can achieve its best quality when we use our hand only.

Step 1: *Draw a square. Divide the square to 8 parts using the lines as the figure below*

Step 2: *Draw a snowflake shape. Notice that the distance from the Center of the snowflake to each tipping point is the same.*

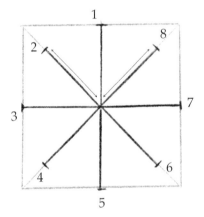

Step 3: *Connect the tipping point 1,2, and 3 by a short curve, which is 1/4 of a circle.*

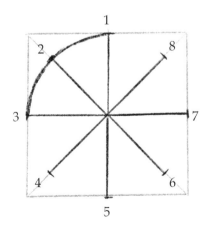

Step 4: *Continue to draw the other short curves until we get the circle*

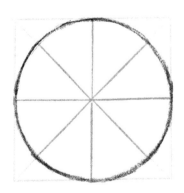

PRACTICES

1. Classic Braid

Step 1:

Draw the lines
to create the
braid's container

Step 2:

Draw the zic-zac lines

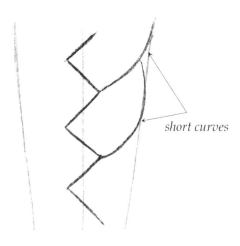

short curves

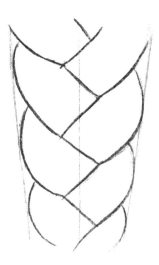

Step 3:

Draw the short curves

Step 4:

Continue to fill
the drawing with
the short curves

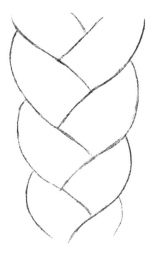

Step 5:

Erase the braid's container to get the full look of the braid's sketch

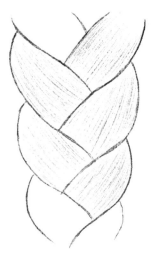

Step 6:

Use a 2B pencil to draw the first GOPLs

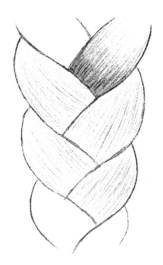

Step 7:

Continue to use a 2B pencil to draw the 2nd GOPL on the first one. The 2nd GOPL's width is equal to one-third of the 1st one

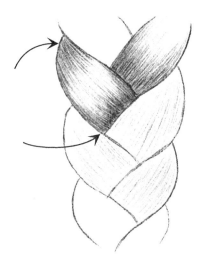

Step 8:

Repeat step 7 on the pointed positions

Step 9:

Finish filling the 2^{nd} GOPLs on the pointed positions below

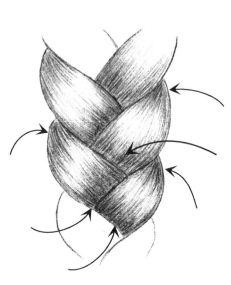

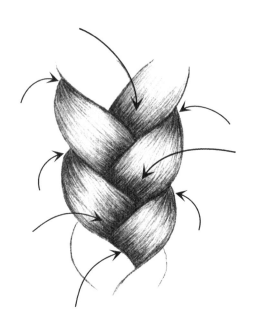

Step 10:

Use a 4B pencil to draw the 3^{rd} GOPL on the pointed positions, and its width is ½ compared to the 2^{nd} GOPL. Polish the braid shape using a 6B pencil to finish the drawing

2. A Fist

Step 1:

Draw the L- lines
as above

Step 2:

Continue to get the
first look of the fist

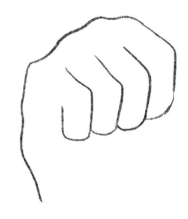

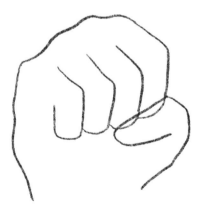

Step 3:

Draw the thumb

Step 4:

Add palm's detail and
use eraser to get a clear
look of the fist

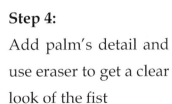

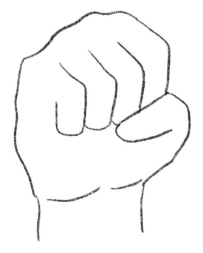

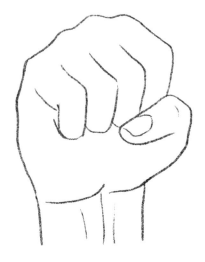

Step 5:

Add detail to polish
the fist's sketch

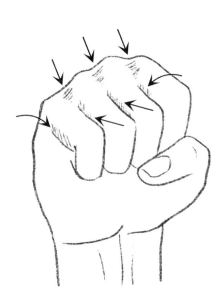

Step 6:

Shading with a 2B
pencil by using parallel
hatching technique to
the pointed positions

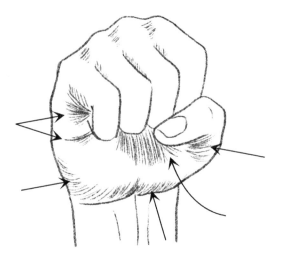

Step 7:

Use contour hatching
technique on the pointed
positions, with a 2B pencil

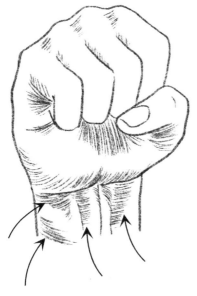

Step 8:

Continue to use contour hatching technique on the pointed positions

Step 9:

Use contour hatching on the fingers

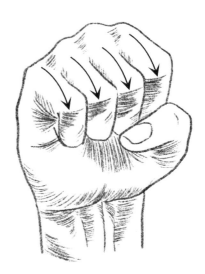

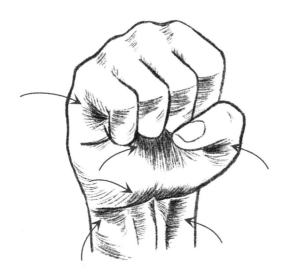

Step 10:

Use a 4B pencil to draw the GOPLs above the first hatching, and their width are ½ compared to the previous GOPLs

3. A Sword

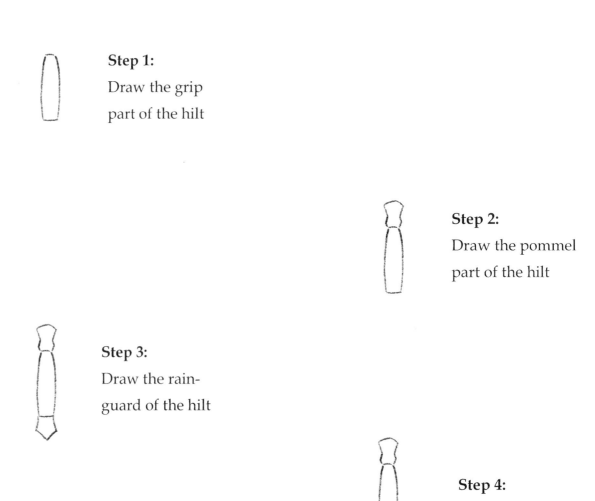

Step 1:

Draw the grip part of the hilt

Step 2:

Draw the pommel part of the hilt

Step 3:

Draw the rain-guard of the hilt

Step 4:

Draw the strong part of the blade

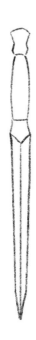

Step 5:

Draw the full shape
of the blade

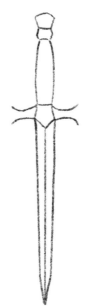

Step 6:

Draw the first part
of the quillons

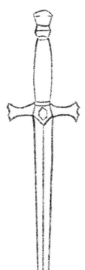

Step 7:

Finish the quillons
& add details to
the hilt

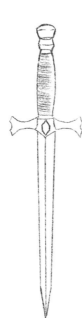

Step 8:
Use a 2B pencil to shade ¾ width of the grip with contour hatching technique

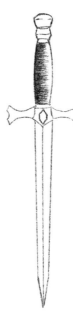

Step 9:
Continue to use 2B pencil to shade ½ width of the grip, applying the same technique in step 8

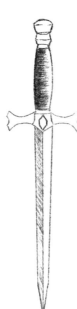

Step 10:
Use a 2B pencil to shade the half part on the left of the blade with parallel hatching technique, where the lines create a 135 degree angle compared to horizontal line.

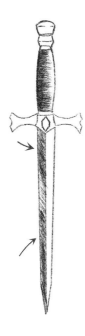

Step 11:

Continue to shade the
half part of the blade
with the same technique
in step 10. Notice to
use a 2B pencil on
the pointed positions.

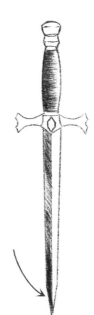

Step 12:

Use a 4B pencil to
shade on the pointed
area.

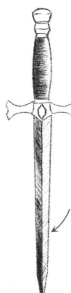
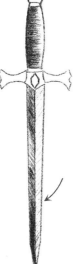

Step 13:

Use a 2B pencil to
shade the half part
on the right of the
blade, applying parallel
hatching technique. The
line in this GOPL
create an angle of
45 degree compared
to horizontal line.

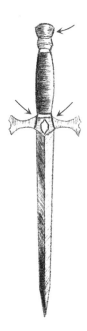

Step 14:
Continue to use
the 2B pencil to
shade on the
pointed areas

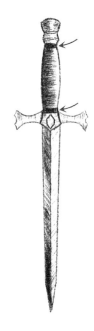

Step 15:
 Use a 4B pencil
to fill black into
the pointed details

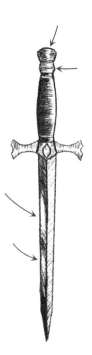

Step 16:
Use a kneaded
eraser to render
the drawing by
removing pencil
shading in the
specific areas, which
creates highlights on
the drawing.

4. A Banana

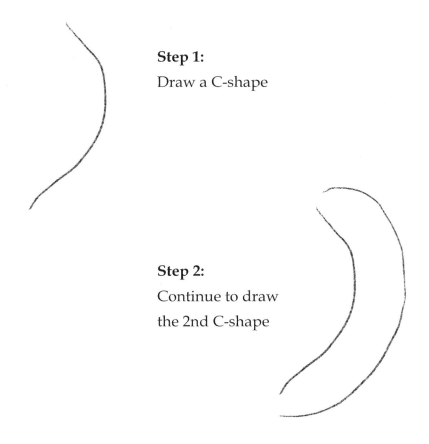

Step 1:

Draw a C-shape

Step 2:

Continue to draw
the 2nd C-shape

Step 3:

Draw the black end
of the banana

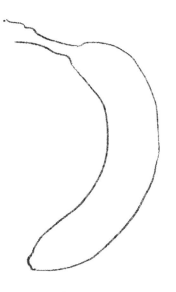

Step 4:

Draw the first part
of the cut stalk

*Notice: Sketch using a
HB pencil*

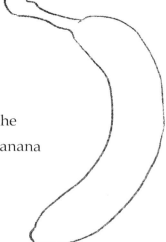

Step 5:

Finish drawing the
cut stalk of the banana

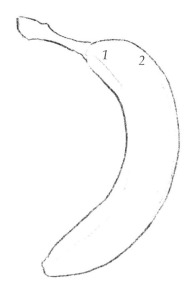

Step 6:

Sketch the border
of light area on
the banana

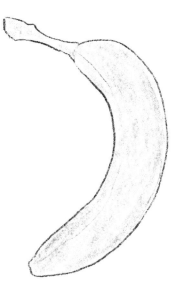

Step 7:

Use a 2B pencil to shade
all the skin of the banana
with very thick lines (combine
the advance drawing tips at
P.19 for the best result)

Step 8:

Using the same technique
in step 7 to shade from
the boundary no.01
to the banana's edge.

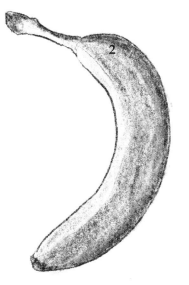

Step 9:

Shade the banana
from the boundary
no.02 to the banana's
edge

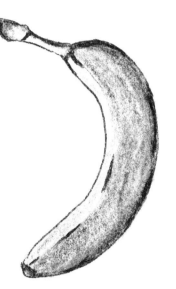

Step 10:

Use a 4B pencil to make the pointed positions darker.

Step 11:

Continue to use the 4B pencil to create the dark area on the banana skin using thick zic-zac lines

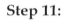

Step 12:

Use a 6B pencil to make the dark area more vivid and contrast, and render the banana using a kneaded eraser by creating the highlights on it.

5. A Hand

Step 1:

Draw a 4:5 ratio rectangle.
Inside that rectangle, draw
a curve, and divide it into 4.

Step 2:

Draw 05 circles represen-
ting the joints between
fingers and palm.

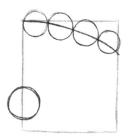

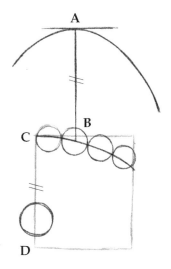

Step 3:

From the middle finger's
circle, draw a straight line
that create 90 degree compared
to the horizontal line. Draw a
curves as the figure, notice that
it passes the A point.

Notice: AB = CD

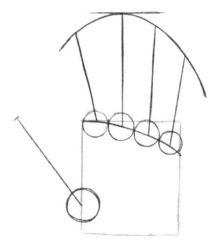

Step 4:

Draw 5 straight lines representing the fingers.

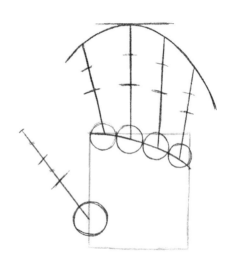

Step 5:

Divide each straight line into 02, and on the top line, continue to divide it into 02 again.

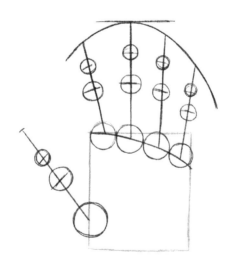

Step 6:

Draw the small circles on the smaller joints on each finger.

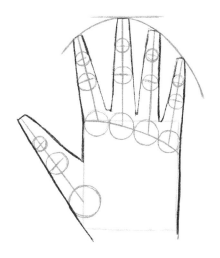

Step 7:

Use a HB pencil to sketch the hand shape

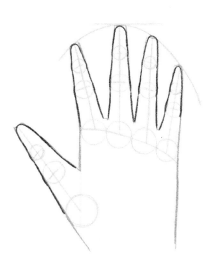

Step 8:

Polish the hand shape

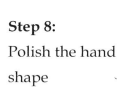

Step 9:

Use a 2B pencil to draw the nails & finish sketching the hand.

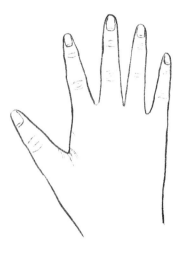

Step 10:

Continue to use a 2B
pencil to draw the folds
on joints of fingers

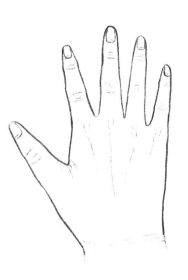

Step 11:

Draw the veins
& folds on the
wrist area

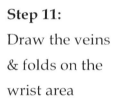

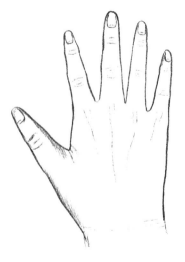

Step 12:

Use a 2B pencil to shade
using parallel hatching
technique on the pointed area.

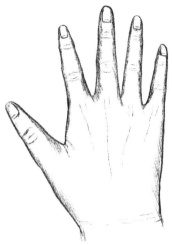

Step 13:

Continue to use a 2B pencil to shade with the same technique on step 12 on the pointed area

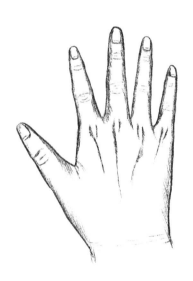

Step 14:

Use parallel hatching with a 2B pencil on the veins

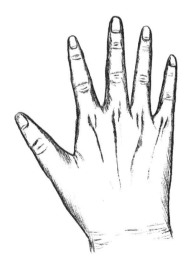

Step 15:

Use a 4B pencil to make the hand details more contrast

6. Diamond

Step 1:

Draw a square.
Divide it into 4
smallers squares

Step 2:

Draw an elip shape
at the middle of the
top line, and mark
the points A and B

Step 3:

Draw the raw
diamond shape

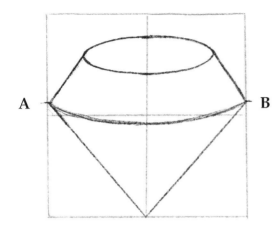

Step 4:

Draw the curve
that connects A
and B

Step 5:

Use an eraser to remove
the diamond's container

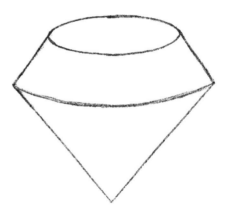

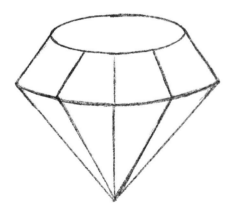

Step 6:

Add detail to finish
the diamond's sketch

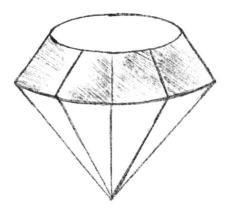

Step 7:

Use a 2B pencil to shade on the pointed area, applying parallel hatching technique.

Step 8:

Continue to use a 2B pencil to shade with the same technique on step 7. Notice that on this layer, each GOPL is ⅓ in width compared to the previous one of the first layer.

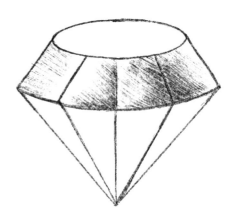

Step 9:

Use a 2B pencil to shade on the top of the diamond.

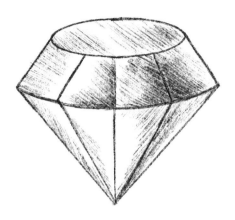

Step 10:

Draw the first layer of GOPLs using a 2B pencil for the purpose of shading the bottom part of the diamond

Step 11:

Continue to use a 2B pencil to draw the 2nd layer of GOPLs to the pointed positions. Each GOPL is equal to ⅓ in width compared to the first layer one.

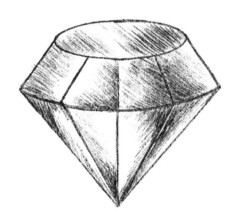

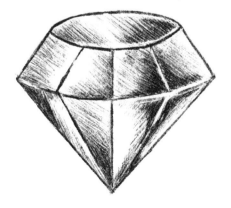

Step 12:

Use a 4B pencil to make the pointed positions bold. After that, use a kneaded eraser to render the drawing.

7. The Impossible Triangle

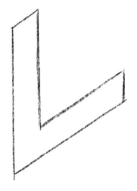

Step 1:

Draw the L-Shape

Step 2:

Draw a rhombus on
the top of the L- shape

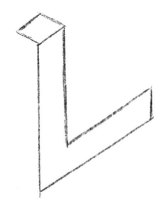

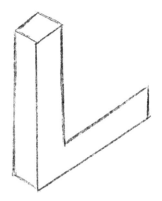

Step 3:

Finish drawing the first
long cube

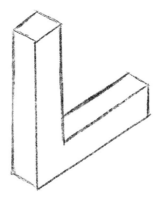

Step 4:

Draw the 2nd
long cube

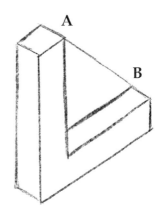

Step 5:

Draw a line to
connect A and B

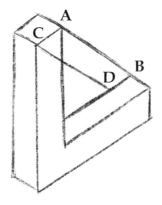

Step 6:

Draw a line connecting
C and D, which is parallel
vwith the AB line

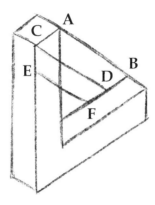

Step 7:

Draw another line connecting E and F, which is parallel to CD and AB lines.

Step 8:

Use an eraser to remove unnecessary lines

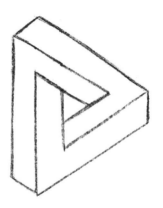

Step 9:

Shade the bottom L-shape using a 4B pencil, applying parallel hatching technique.

Step 10:

Use a 2B pencil to apply parallel hatching on another L-shape

Step 11:

Make it bold on the pointed corners using a 4B pencil with parallel hatching technique

Step 12:

Finish the drawing by adding another GOPLs on the previous shading layers using 2B pencil.

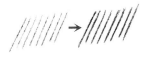

8. The Water Drop

Step 1:

Draw an oval shape using a HB pencil

Step 2:

Use a 2B pencil to shade with thick & long curves. We call this shading layer as A, and its width is ½ compared to the oval's width.

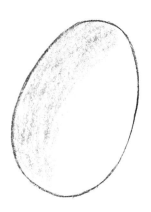

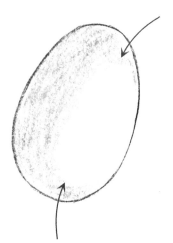

Step 3:

Use a 2B pencil to shade with the same technique on step 2 to the pointed area

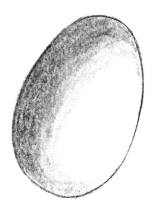

Step 4:

Draw the B layer using a
2B pencil on the A layer.
B layer's width is ⅔
compared to A.

Step 5:

Use a HB pencil to
draw the shadow
boundary of the
water drop

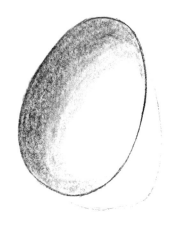

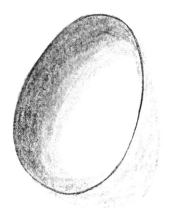

Step 6:

Fill into the shadow
the pencil thick curves
using 2B pencil

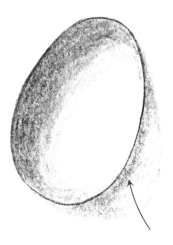

Step 7:
Continue to use the
2B pencil to make the
pointed area bold.

Step 8:
Add darker layers on
the pointed area to make
the water drop's illusion
more clear to appear.

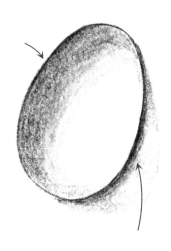

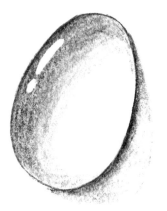

Step 9:
Use a kneaded eraser to
create the "!" shape for
the purpose of rendering
the water drop.

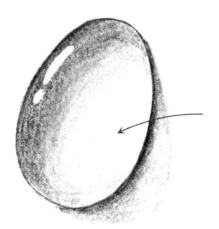

Step 10:

Use a HB pencil to colorize lightly on the pointed area.

Step 11:

Use a 6B pencil to make the pointed dark areas darker.

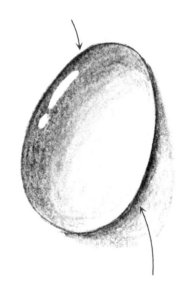

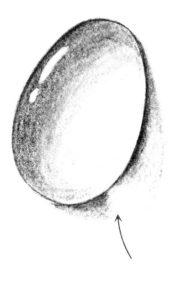

Step 12:

Use a kneaded eraser to create the refraction effect for the water drop to make it realistic.

9. A Pineapple

Step 1:

Draw a fat egg shape using HB pencil

Step 2:

Divide the left and right edge into 6 by drawing the points, and draw a straight line to make the top and bottom flat.

Step 3:

Draw continuous short curves along the pineapple left and right side.

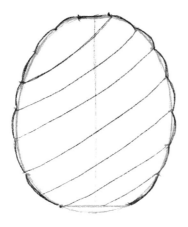

Step 4:

Draw 06 curves
from the right to
the left as the figure

Step 5:

Continue to draw 06
curves from the left
to the right

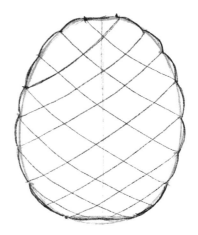

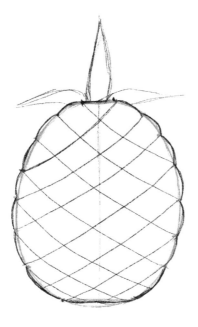

Step 6:

Sketch the first part
of pineapple's crown

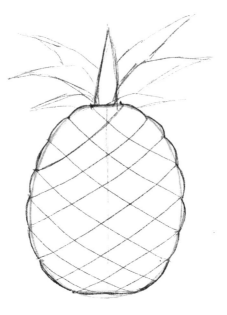

Step 7:

Continue to draw
the crown's sketch

Step 8:

Finish sketching the crown

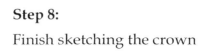

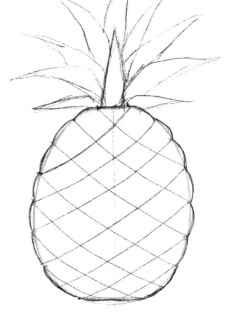

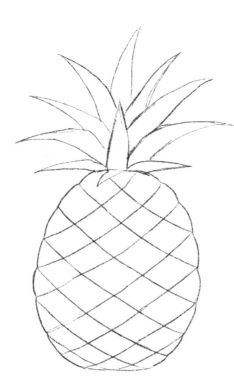

Step 9:

Render the pineapple's sketch

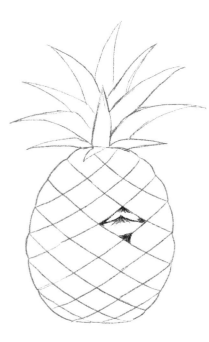

Step 10:

Use a 4B pencil to shade the pineapple by applying hatching technique inside each small rhombus on the pineapple's skin

Step 11:

Repeat step 10 inside another rhombus

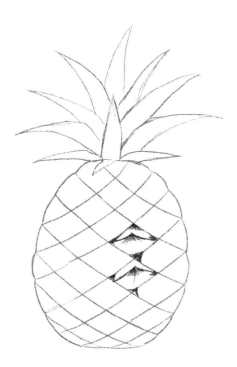

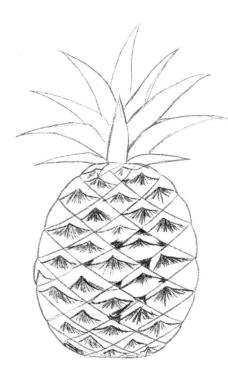

Step 12:

Fill all the rhombuses on the pineapple's skin as this picture.

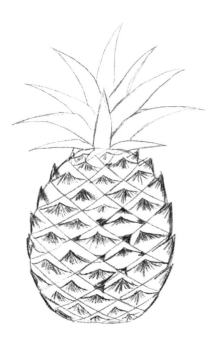

Step 13:

Use a 4B pencil to shade the triangle on the right and left edge of the pineapple, using this quick tutorial

Step 14:

Use a 4B pencil to draw the serrated pineapple leaves

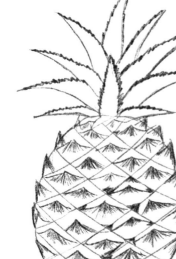

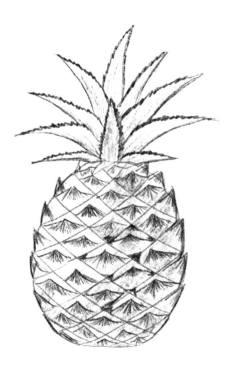

Step 15:

Shade all the leaves and ¾ of the pineapple's skin using a 2B pencil.

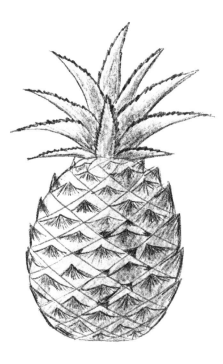

Step 16:

Use a 2B pencil to shade the dark area of the pineapple leaf, and its height is ⅔ compared to the full leaf.

Shade ½ the pineapple's skin with thick pencil lines.

Step 17:

Continue to use a 2B pencil to shade ¼ of the pineapple's skin.

Use a 4B pencil to shade ⅓ the pineapple leaf vertically

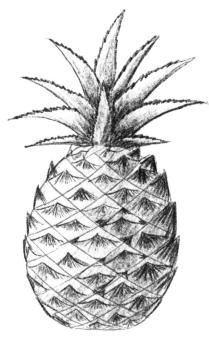

Step 18:

Use a 6B pencil to make the pointed area really dark.

dark

← dark

Create the pineapple's shadow using a 4B pencil

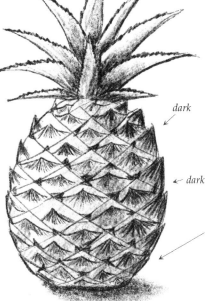

10. The Crown

Step 1:

Draw a special U-shape with a curve on the bottom

Step 2:

Draw another curve

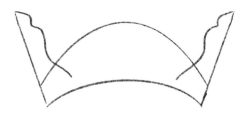

Step 3:

Draw the first part of the fleur-des-lys

Step 4:

Finish the shape of the fleur-des-lys and draw the first part of the arch

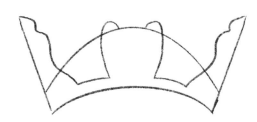

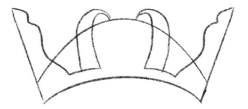

Step 5:

Finish the shape of the arch

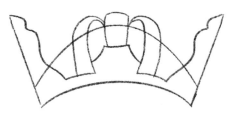

Step 6:

Draw the monde

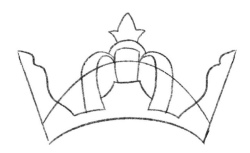

Step 7:

Draw the royal cross

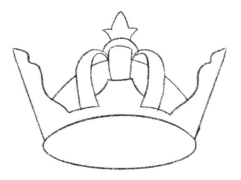

Step 8:

Use an eraser to remove
the unnecessary line & draw
the outline of the band

Step 9:

Finish drawing the
shape of the band

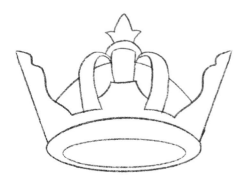

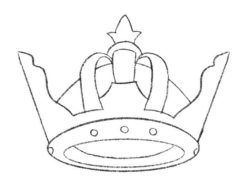

Step 10:

Add the jewelry
into the band

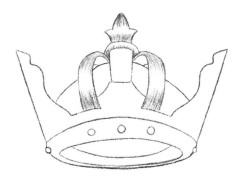

Step 11:

Use a 2B pencil to shade the arch & the royal cross, applying contour hatching technique

Step 12:

Shade the fleur-des-lys using a 2B pencil. Applying parallel hatching technique this time

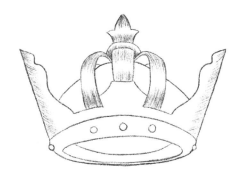

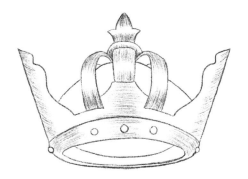

Step 13:

Use a 2B pencil to shade the band and the cap on the pointed position, applying contour hatching technique

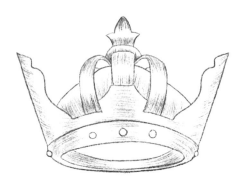

Step 14:

Continue to use 2B pencil
to shade the pointed area,
still applying the same shading
technique on step 13.

Step 15:

Use a 4B pencil & applying contour
hatching technique to shade the arch.

This layer is ¾ in width compared to
the 2B shading layer on the arch.

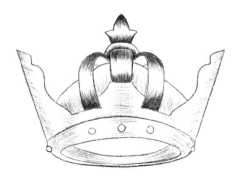

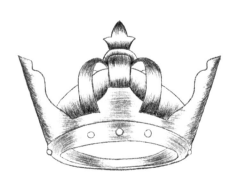

Step 16:

Continue to use a 4B pencil & parallel
hatching on the fleur-des-lys. This 4B
layer is ¾ in width compared to the
2B layer.

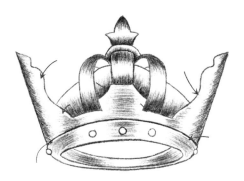

Step 17:

Use a kneaded eraser to add highlights on the pointed area

Step 18:

Draw the container of highlight area using 4B pencil

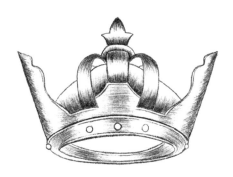

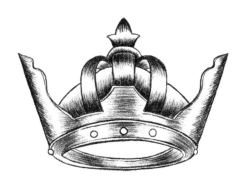

Step 19:

Use a 6B pencil to make the dark area bold, which increase contrast on the drawing.

11. Peony Flower

Step 1:
Draw the first
group of petals

Step 2:
Add more petals to
the current group

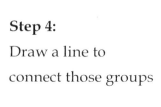

Step 3:
Draw another petals
group on the top-right
of the current sketch

Step 4:
Draw a line to
connect those groups

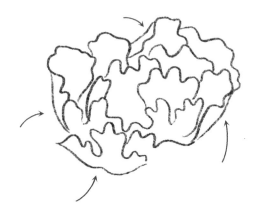

Step 5:

Adding more petals at
the bottom of the sketch

Step 6:

Add more details

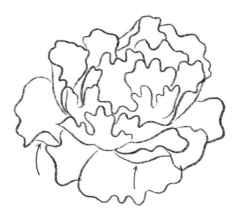

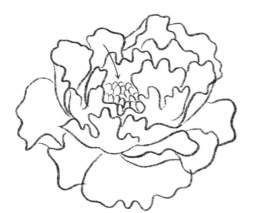

Step 7:

Draw the pistil

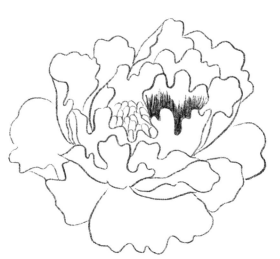

Step 8:

Use a 2B pencil to shade the first petal. applying the contour hatching technique.

Step 9:

Applying the same technique of step 8 for other petals

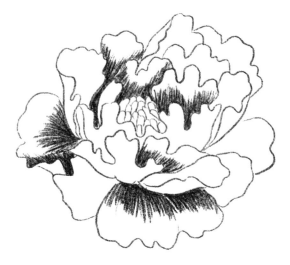

Step 10:

Continue to fill the first shading layer for all of the petals

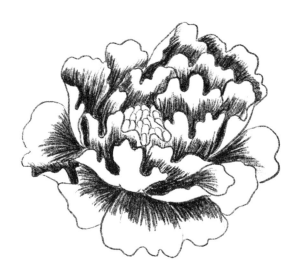

Step 11:

Finish the first

shading layer

Step 12:

Use a 4B pencil to make the
area between the petals really dark.

Use a 2B pencil to shade
the petals on the pointed area

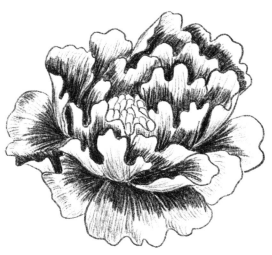

Step 13:

Use a HB pencil to shade
on other blank areas

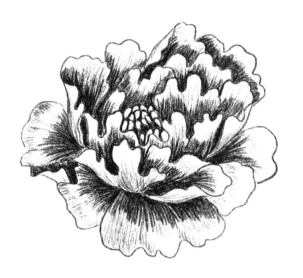

Step 14:

Use a 6B pencil to create the

darkest area on the petals

Step 15:

Use a 4B pencil to

shade the pistil.

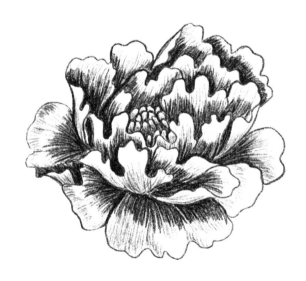

12. A Leaf

Step 1:

Draw the petiole & midrib

Step 2:

Draw the shape
of the leaf blade

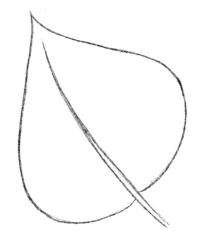

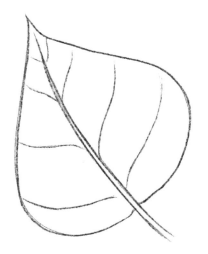

Step 3:

Draw the first lines
of veins on the leaf

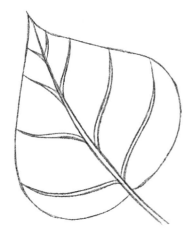

Step 4:

Finish drawing
the leaf's veins

Step 5:

Draw the realistic
margin of the leaf

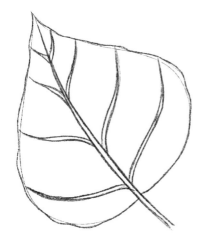

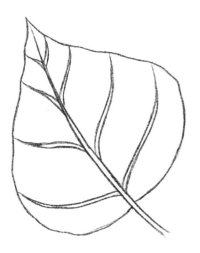

Step 6:

Use an pencil eraser
to remove the leaf
blade container

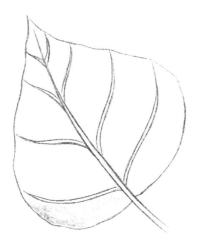

Step 7:

Use a 2B pencil to shade the first venule by continuous thick zic-zac lines

Step 8:

Apply the same technique on step 7 to create the first shading layer on the leaf

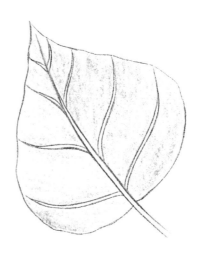

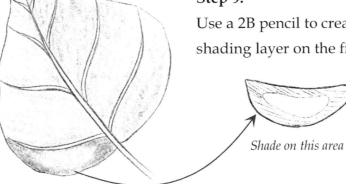

Step 9:

Use a 2B pencil to create the 2nd shading layer on the first venule.

Shade on this area

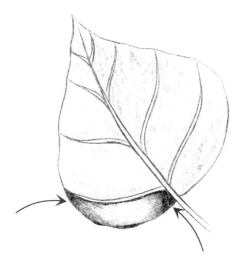

Step 10:

Use a 4B pencil to make
those pointed areas darker

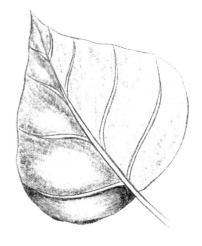

Step 11:

Repeat step 9 on all the venules
on the left of the midrib

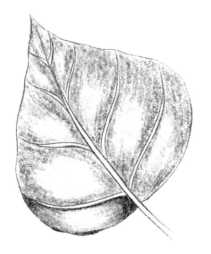

Step 12:

Repeat step 9 on all the venules
on the right of the midrib

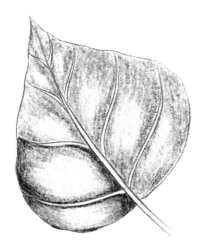

Step 13:
Repeat step 10 on
the 2nd venule

Step 14:
Use a 4B pencil to make
the pointed area darker

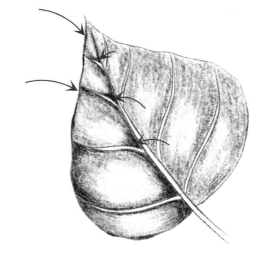

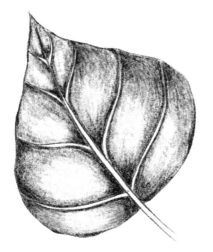

Step 15:
Shading the same for
all the venules on the
right of the midrib

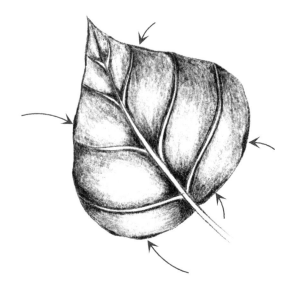

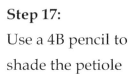

Step 16:

Use a 6B pencil to make the pointed areas the darkest one, for the purpose of creating the contrast effect

Step 17:

Use a 4B pencil to shade the petiole

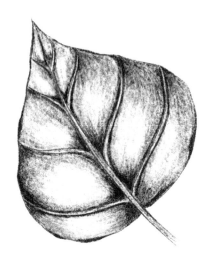

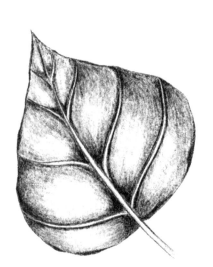

Step 18:

Use a kneaded pencil to create highlights on the petiole and veins of the leaf.

13. The Lips

Step 1:

Draw the lines & divide them as the figure

Step 2:

Draw the cupid bow and the curves

Step 3:

Draw the upper vermilion border

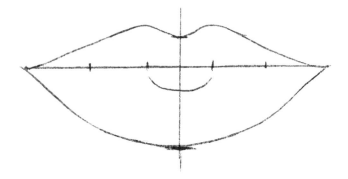

Step 4:

Draw the lower
vermilion border

Step 5:

Draw the curve
between the lips

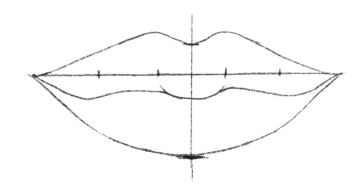

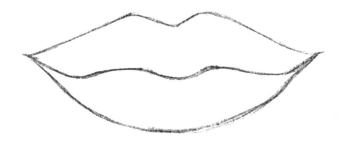

Step 6:

Erase the lips' container

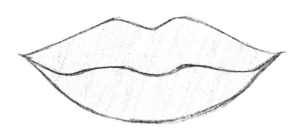

Step 7:

Shade all the lips with
thick zic-zac lines using
a 2B pencil

Step 8:

Use a 2B pencil to shade
the lower lip, applying
contour shading technique

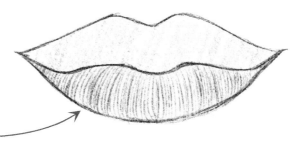

Step 9:

Use a 4B pencil to
shade the lower lip
on the pointed areas

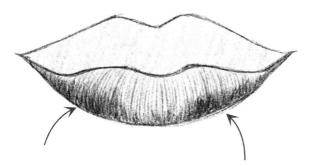

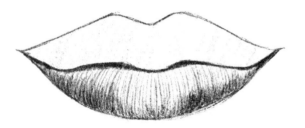

Step 10:
Continue to use a 4B pencil to make the curves between two lips really dark

Step 11:
Shading using zic-zac lines technique, transparent from dark to light on the direction from near to far the curve between two lips

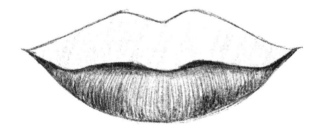

Step 12:
Use a 2B pencil to shade very lightly on the lower lip.

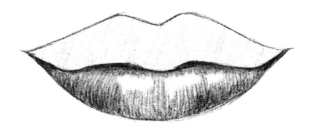

erase as this shape

Step 13:

Use a kneaded eraser to create highlights on the lower lip, using this mini tutorial below

Step 14:

Use a 2B pencil to draw the curves on the upper lip

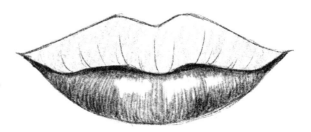

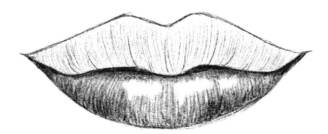

Step 15:

Use a 2B pencil to apply contour hatching on the upper lip

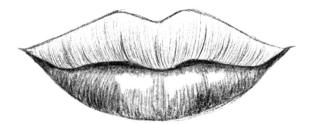

Step 16:

Make the curves on step 14 bold by using a 4B pencil

Step 17:

Use a kneaded eraser to create highlights on the upper lip. Shading with contour hatching technique on the pointed area.

shading *highlight*

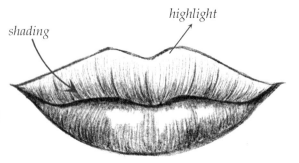

Step 18:

Use a 6B pencil to make the pointed area darker, which create high contrast for the drawing.

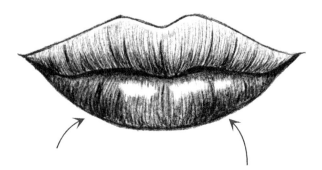

14. An Apple

Step 1:

Draw a square as
the apple's container

Step 2:

Create a round shape
inside the square

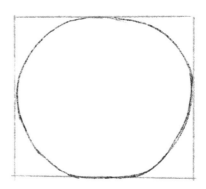

Step 3:

Draw the apple stalk

Step 4:

Erase the apple container

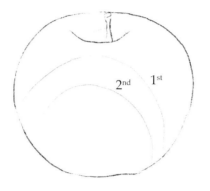

Step 5:

Draw the 1st
and 2nd curves

Step 6:

Use a 2B pencil to shade all the apple,
applying contour hatching technique.

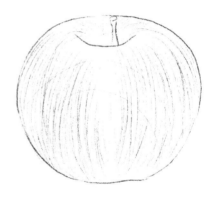

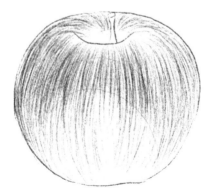

Step 7:

Continue to create the 2nd shading
layer that covers the area above 2nd
curve with contour hatching
technique, using 2B pencil.

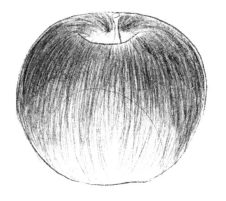

Step 8:

Create the 3rd shading layer which covers the area above 1st curve using a 2B pencil, with contour hatching technique.

Step 9:

Use a 4B pencil to create the 4th shading layer. This layer width is ¾ compared to the 3rd one

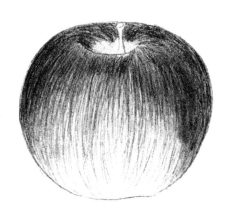

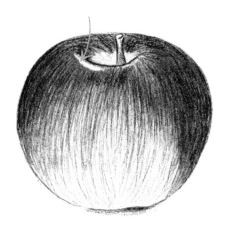

Step 10:

Use a kneaded eraser to make a highlight on the pointed area

13. The Cracked Wall

Step 1:

Draw a rectangle. Inside the rectangle, sketch the first border of the cracked wall

Step 2:

Finish drawing the shape of the cracked wall

Step 3:

Eraser the cracked

wall's container

Step 4:

Draw the cracked

lines on the wall

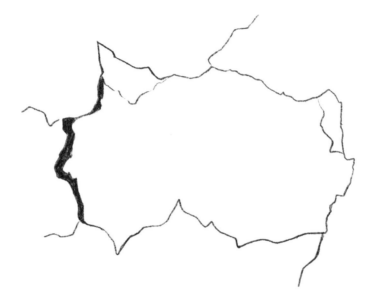

Step 5:

Use a 6B pencil to fill the
pointed area black to create
the thickness on the left
of the wall

Step 6:

Continue to use the
6B pencil to create
thickness for all the wall

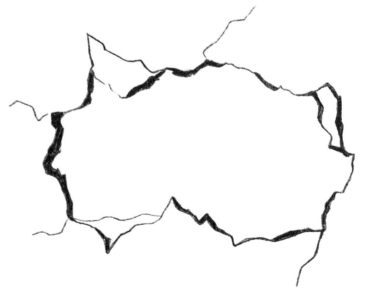

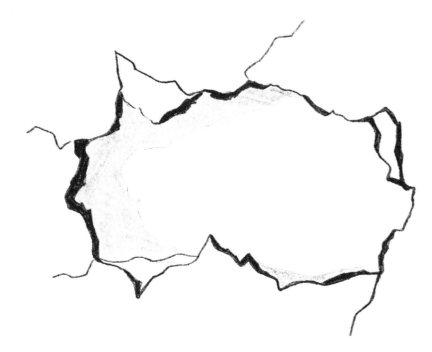

Step 7:

Use a 2B pencil to shade with thick zic-zac lines on the pointed area

Step 8:

Create the 2nd shading layer that has a width of ½ compared to the previous one, using a 4B pencil.

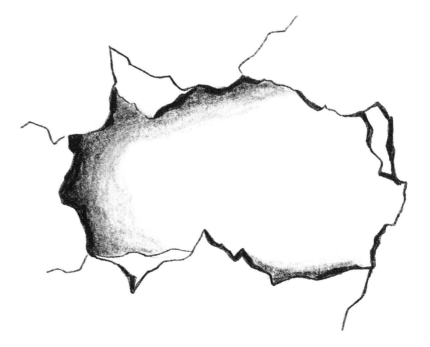

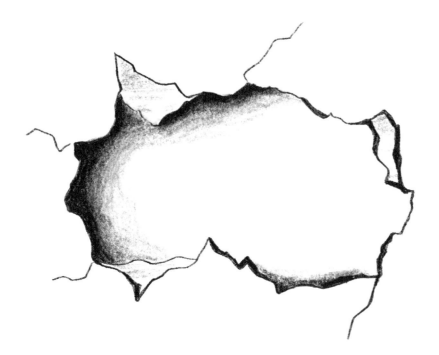

Step 9:

Change to use the 2B pencil to shade on the pointed areas.

Step 10:

Use the 6B pencil to make the cracked line bold & add the details on the wall, and draw the horizontal lines by a HB pencil

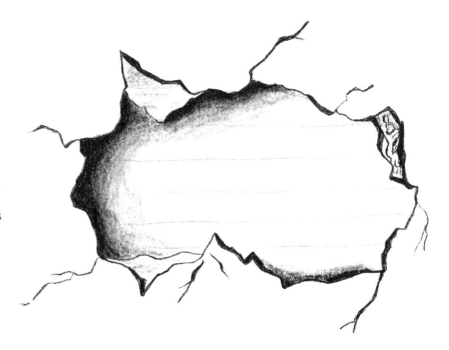

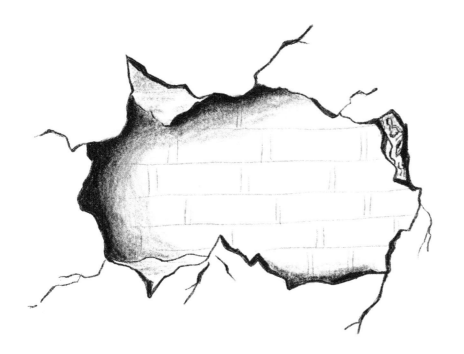

Step 11:

Sketch the bricks
using a HB pencil

Step 12:

Use the 2B pencil
to complete drawing
the bricks

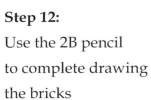

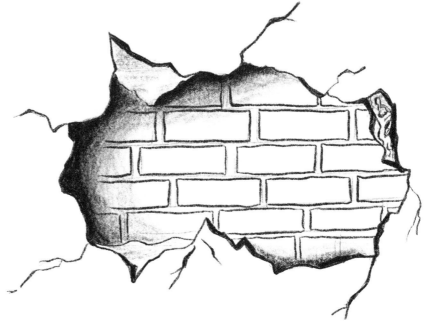

Step 13:

Make the bricks appear three dimensional by adding a drop shadow on the right bottom each brick, using a 6B pencil

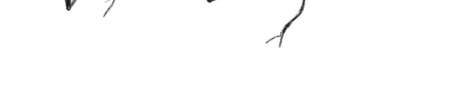

Step 14:
Use a 6B pencil to
add the cracked texture
on each brick.

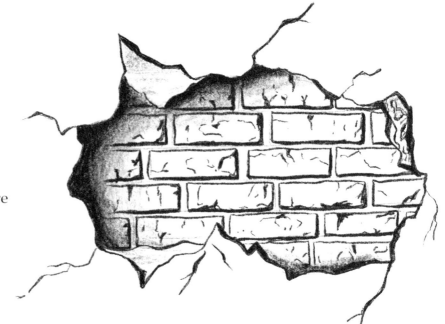

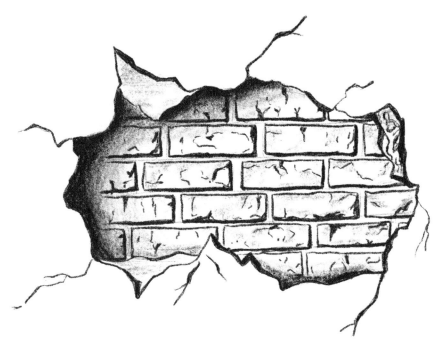

Step 15:

Create a realistic look of each brick using a 2B pencil & zic-zac thick lines to shade on the bricks.

Take a look to figure out how to do it using this sample brick

Step 16:

Make the cracked wall more vivid by using a 4B pencil to shade on each brick.

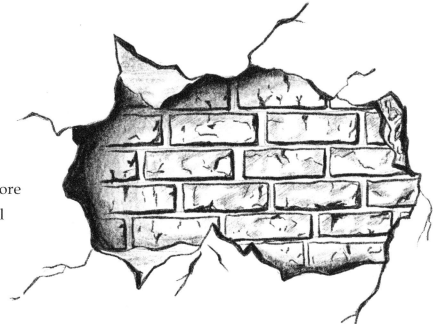

14. The Eyes

Step 1:

Draw a circle

Step 2:

Divide the circle
into 5 horizontally

Step 3:

Draw a curve on the first
border line & add a dot
at the center of the eye.
Extend the 4th line and
mark the A, B and C point
as the picture

A B

C

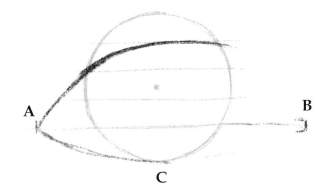

Step 4:

From A, draw a curve passing C. Draw a reverse C-shape at B to describe the shape of lacrimal caruncle.

Step 5:

Finish sketching the first look of the eye

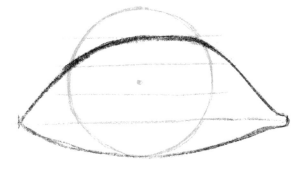

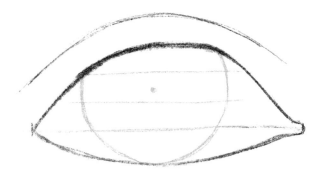

Step 6:

Draw the eyelid's upper border

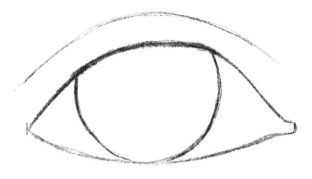

Step 7:

Eraser unnecessary details

Step 8:

Draw the pupil & highlight
areas inside the eye.

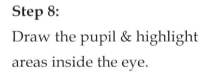
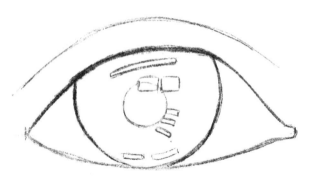

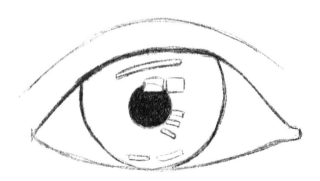

Step 9:

Use a 6B pencil to fill
the pupil black

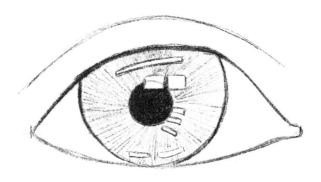

Step 10:

Shade the iris using straight lines from the pupil to the iris's border with a 2B pencil.

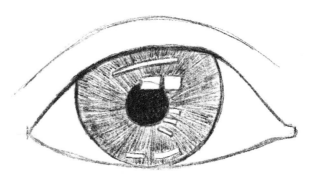

Step 11:

Continue to use 2B pencil to shade another layer on the previous one

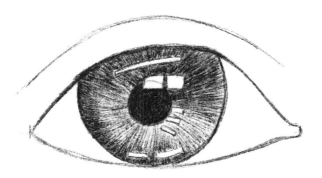

Step 12:

Create the 3rd shading layer using the mini tutorial below Use a 4B pencil to shade on the pointed area.

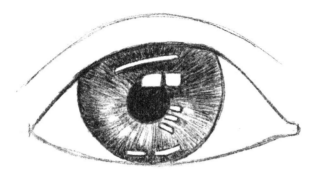

Step 13:

Use the 4B pencil to draw the border.

Use a kneaded eraser to make the highlight areas appear clearly and vividly

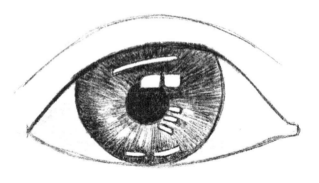

Step 14:

Shade slightly on the sclera using a 2B pencil

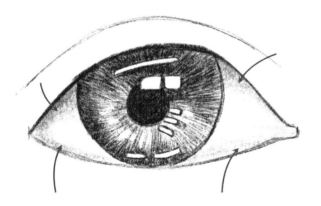

Step 15:

Use a 2B pencil to create the 2nd shading layer on the sclera

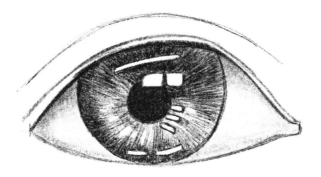

Step 16:

Draw another border of
the eyelid using a 2B pencil.

Step 17:

Shade the bottom area
of the upper eyelashes

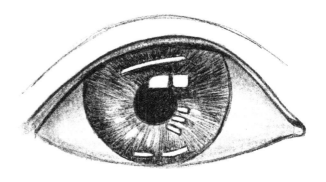

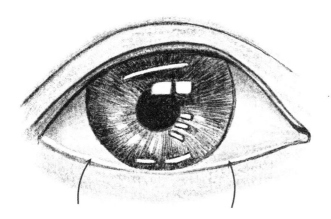

Step 18:

Shade slightly on the
upper and lower eyelids.
Use the kneaded eraser
to create a highlight on
the pointed areas.

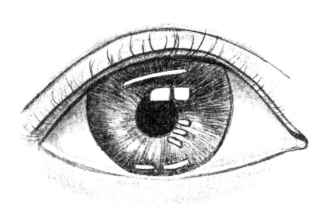

Step 19:

Use a 4B pencil to draw the first shor eyelashes layer from the bottom to th top decisively

Notice about the eyelashes' length: they are short near the lacrimal caruncle but long in the middle and the lateral canthal of the eyes

Step 20:

Draw the 2nd and 3rd eyelashes layers using the 4B pencil. Be aware to put 2-3 eyelashes into one group, which will make them look more natural

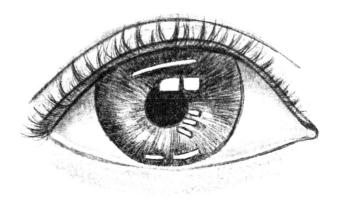

DO DON'T

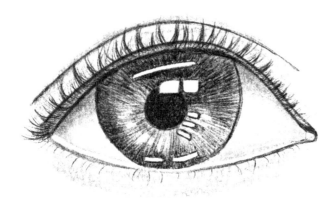

Step 21:

Draw the lower eyelashes using a 4B pencil

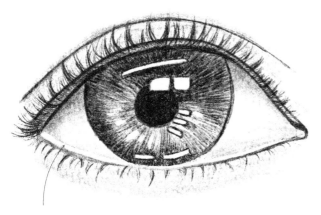

Use a kneaded eraser to
create this highlight

Step 22:

Continue to draw the lower eyelashes, applying the same technique on step 20

Step 23:

Use the 4B pencil to add the drop shadow of the eyelashes on the highlight areas inside the pupil

drop shadow of eyelashes

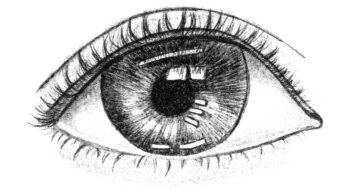

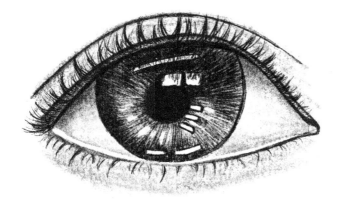

Step 24:

Use a 6B pencil to make the dark area darker for creating a great contrast for the final drawing.

15. A Rabbit

Step 1:

Draw a square and divide it into 4, then draw the curves inside this square shape.

Step 2:

Draw another curve as this picture

Step 3:

Draw the first rabbit ear

Step 4:

Draw the second rabbit ear

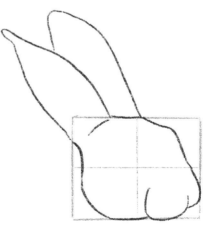

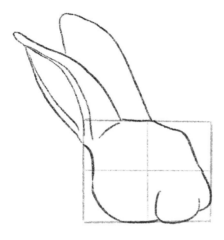

Step 5:

Draw the inner edge of
the first rabbit ear.

Step 6:

Add an eye on the rabbit face

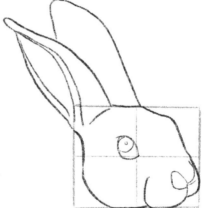

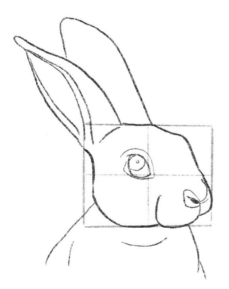

Step 7:

Draw the rabbit eyelids
and a part of its body

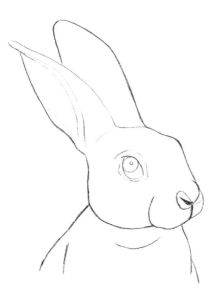

Step 8:

Remove the rabbit container
to get a clear sketch

Step 9:

Use a 2B pencil to shade the pointed area
using this group of random straight lines

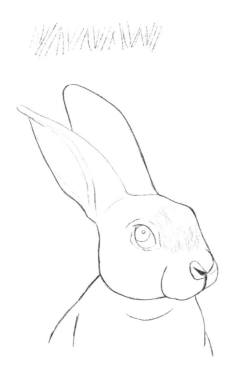

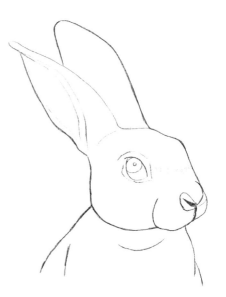

Step 10:

Continue to apply the same technique on
step 9 to shade the pointed area with a 2B
pencil

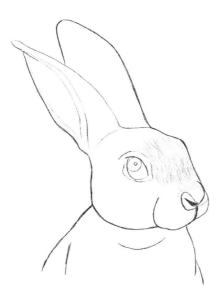

Step 11:

Shade the rabbit nose tip using this specific group of straight short lines with a 2B pencil

Step 12:

Continue to shade the nose tip area using a 2B pencil

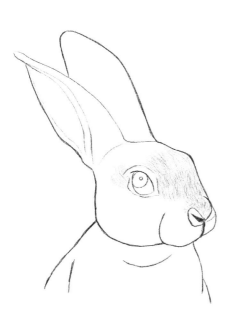

Step 13:

Shade the pointed area near the rabbit eye, using a group of short contour lines with a 2B pencil.

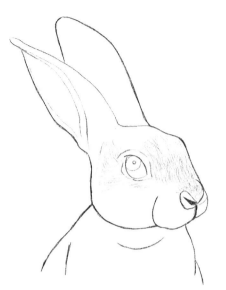

Step 14:

Create a shading layer under the rabbit eye, using a group of straight horizontal lines with a 2B pencil.

Step 15:

Shade the cheeks' sides with a 2B pencil.

Step 16:

Continue to shade all the cheeks using a group of straight horizontal lines

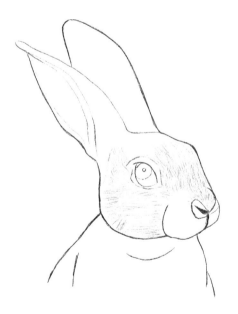

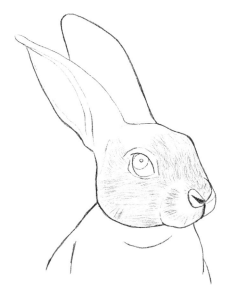

Step 17:

Use a 2B pencil to shade the fur on the rabbit nose that create an arc shape

Step 18:

Continue to shade all the rabbit nose using a 2B pencil

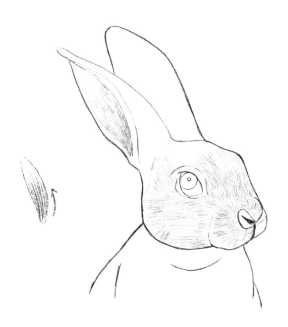

Step 19:

Shade the inside area of the rabbit ear.

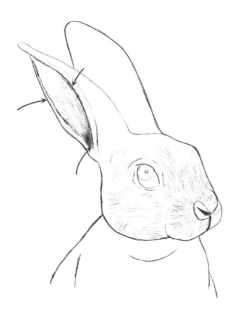

Step 20:

Use a 4B pencil to shade the outer edge of the rabbit ear using zic-zac lines. Make it darker at the bottom corner of the ear.

Step 21:

Shade the inner edge of the rabbit ear using a 4B pencil, applying messy zic-zac lines shading technique.

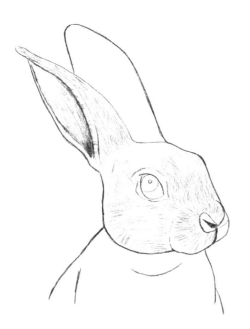

Step 22:

Use a 2B pencil to create the first shading layer on the rabbit ear, using a group of straight lines as the mini tutorial above.

use this group of straight lines for all the ear.

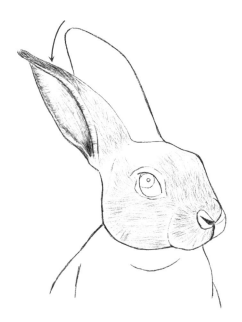

Step 23:

Make the top area of the rabbit ear darker using a 4B pencil.

Step 24:

Use a 2B pencil to shade the fur on the rabbit face

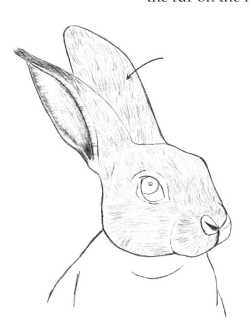

Step 25:

Applying the same tutorial on step 22 to shade another ear.

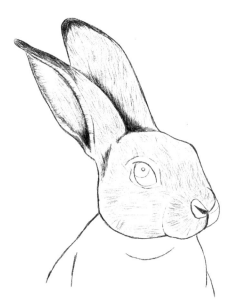

Step 26:

Use a 4B pencil to create a darker shading layer on the top area on the ear, and the area between two ears

Step 27:

Shade all the rabbit eye using a 2B pencil.

Step 28:

Use a 6B pencil to make all the eye dark, except a highlight point.

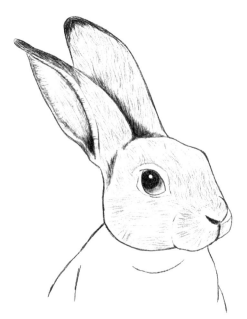

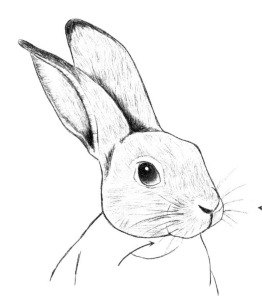

Step 29:

Draw the rabbit mustache
using a 4B pencil

Step 30:

Shade the part of the rabbit
body with a 2B pencil, using
groups of zic-zac lines.

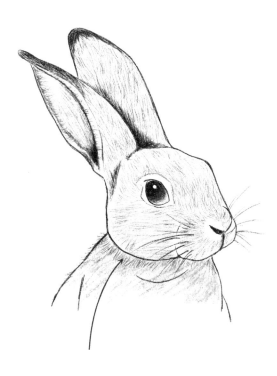

Step 31:

Use a 2B pencil to create another
short straight lines shading layer
on the area under the rabbit neck.

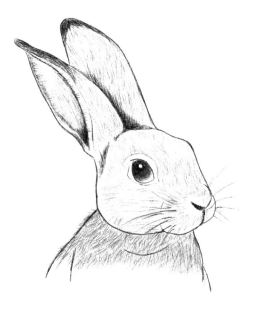

Step 32:

Continue to use the 2B pencil to fulfill the body part of the rabbit to create the rabbit fur on its body

Step 33:

Use a 2B pencil to draw the fur on the rabbit face using short, straight lines

Notice that the short, straight lines are having the same direction with the first shading layer on the rabbit face.

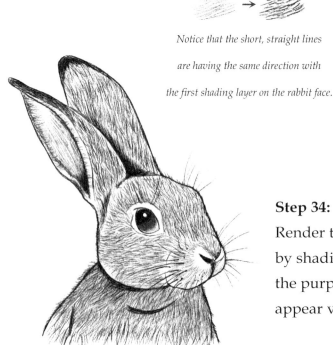

Step 34:

Render the drawing using a 6B pencil by shading to the darkest areas, for the purpose of making the rabbit appear vividly.

16. A Cat

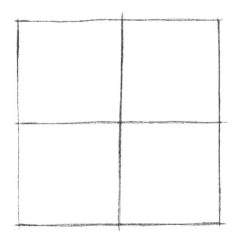

Step 1:

Draw a square and divide it into 4

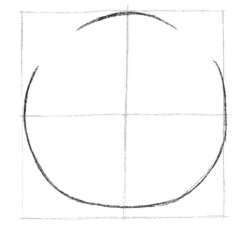

Step 2:

Draw the curves

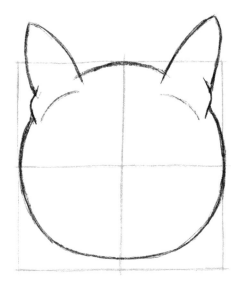

Step 3:

Draw the cat's ears

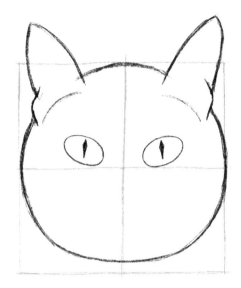

Step 4:
Draw the first cat's
eyes shape

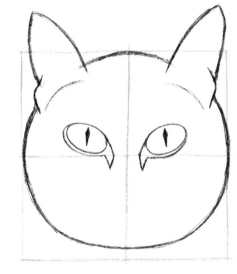

Step 5:
Draw the cat's
lacrimal caruncle

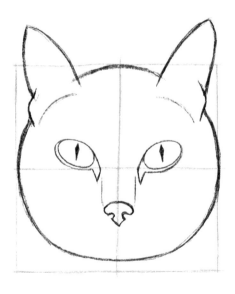

Step 6:
Draw the cat's nose

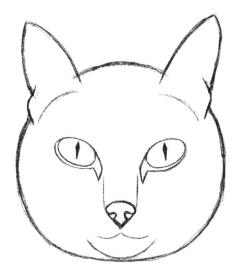

Step 7:

Add the mouth and chin

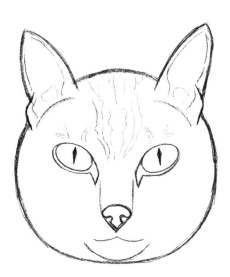

Step 8:

Use a HB pencil to sketch the texture on the cat's fur

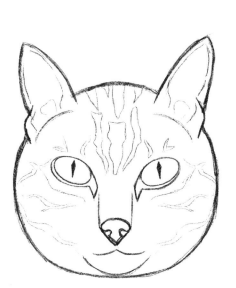

Step 9:

Continue to draw the texture's outline

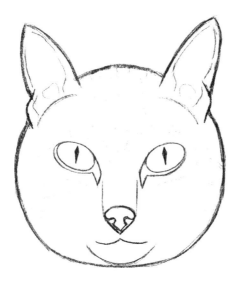

Step 10:

Use an eraser to remove slightly the texture outline on the cat fur

1st shading layer

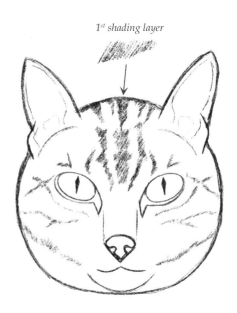

Step 11:

Use a 2B pencil to create the first shading layer using parallel hatching on the previous texture outline area

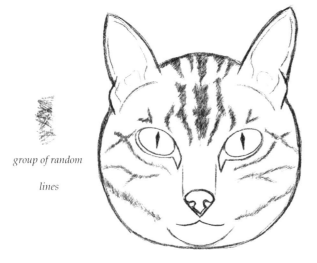

group of random

lines

Step 12:

Continue to create groups of random lines on the first shading layer

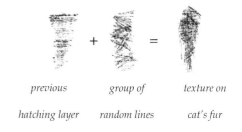

previous *group of* *texture on*

hatching layer *random lines* *cat's fur*

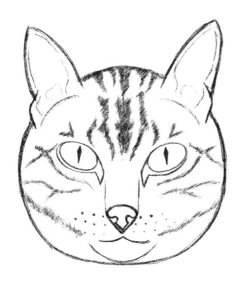

Step 13:

Use a 4B pencil to draw the dot around the cat's mouth

This is the shading layer along the cat's nose sides

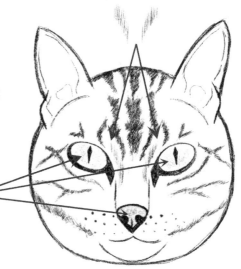

Step 14:

Create shading layer applying parallel hatching technique, with a 2B pencil

Use a 2B pencil to shade all the sclera & nose tip. Make the bottom area of the eyes & the nose tip darker using a 6B pencil

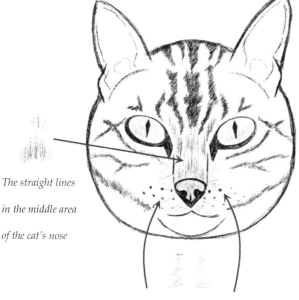

The straight lines in the middle area of the cat's nose

Step 15:

Use the 2B pencil to shade the middle area of the cat nose

Apply contour hatching technique to shade the area nearby the nose sides of the cat

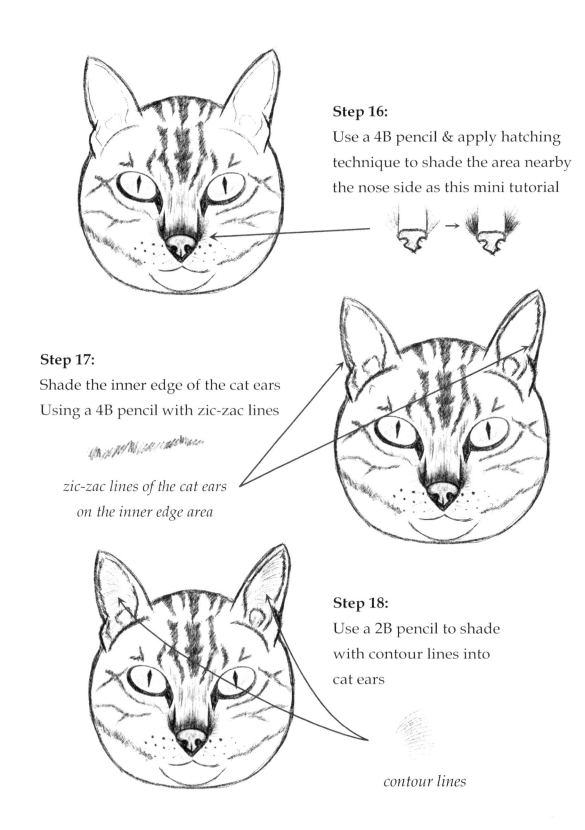

Step 16:

Use a 4B pencil & apply hatching technique to shade the area nearby the nose side as this mini tutorial

Step 17:

Shade the inner edge of the cat ears Using a 4B pencil with zic-zac lines

zic-zac lines of the cat ears on the inner edge area

Step 18:

Use a 2B pencil to shade with contour lines into cat ears

contour lines

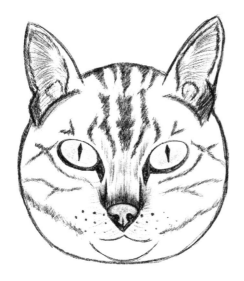

Step 19:

Use a 2B pencil to shade the area under the Cat ears using cross hatching technique

Use this mini tutorial to shade

Step 20:

Use a 4B pencil to shade the cat face sides and under the chin area, which applies zic-zac lines shading technique

create the messy zic-zac lines to deliver the most natural look on the fur

Step 21:

Use the 4B pencil to shade the cat mouth's area. Continue to use the 4B pencil to shade the cat neck, using cross hatching technique.

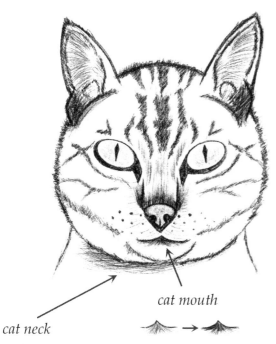

cat mouth

cat neck

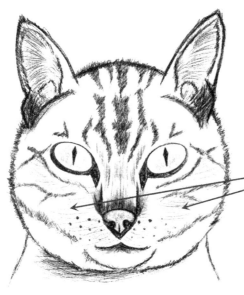

Step 22:

Use a 2B pencil to shade pointed areas on the cat cheeks, applying contour hatching technique

group of contour lines

on the cat cheeks

Step 23:

Continue to shade the cat cheeks using a 2B pencil

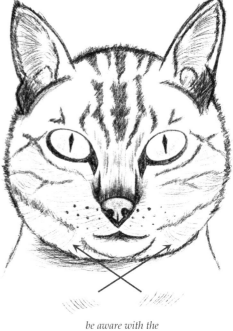

be aware with the

cat fur's direction

Step 24:

Use the 2B pencil to shade the cat forehead area

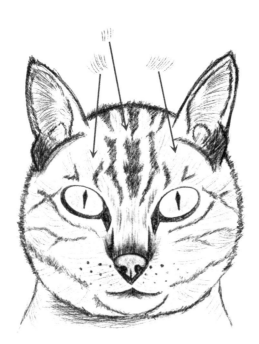

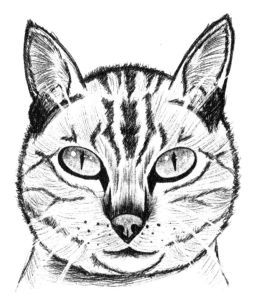

Step 25:

25.1. Use a 4B pencil to create another darker shading layer on the cat fur texture (step 11)

25.2. Use the kneaded eraser to create the cat mustache & eyebrows.

25.3. Shade another layer on ½ of the cat eyes vertically (from the top to the bottom).

25.4. Make 03 highlight areas on each of the cat eyes using a kneaded eraser.

Step 26:

Use a 2B pencil to make another shading layer with short contour lines on the cat faces

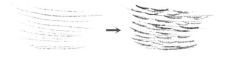

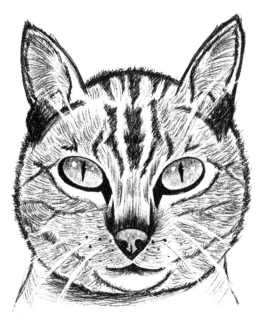

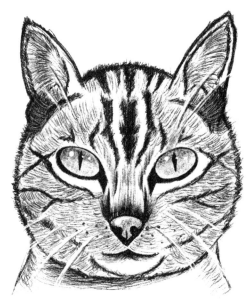

Step 27:

Render the drawing with a 6B pencil by adding one more shading layer on the darkest areas on the cat faces. This action will increase the contrast & sharpen the drawing.

Printed in Great Britain
by Amazon